Digital SRL
Crash Course!

A Beginner's Guide to Understanding Digital Photography & Take the Best Shots of Your Life

By William Wyatt

Disclaimer

The information provided in this book is designed to provide helpful information on the subjects discussed. The author's books are only meant to provide the reader with the basics knowledge of the topic in question, without any warranties regarding whether the reader will, or will not, be able to incorporate and apply all the information provided. Although the writer will make his best effort share her insights, the topic in question is a complex one, and each person needs a different timeframe to fully incorporate new information. This book, nor any of the author's books constitute a promise that the reader will learn anything within a certain timeframe.

Table of Contents

Introduction: Are You Ready for an Amazing Journey?

Chapter 1: A Brief History of Digital Photography

Chapter 2: The Ins and Outs of Digital SLRs (Aperture, Shutter Speed, Balance)

Chapter 3: The Big Guide to Camera Gear (Here's All You Need...)

Chapter 4: Photos as Art - See the World Through a Photographer's Lens

Chapter 5: Tricks of the Trade (Exposure, Lens, HDR)

Chapter 6; What Type of Photographer Are You? (Yes, There's More Than One Kind)

Chapter 7: Crash Course to Promotion (From Instagram to Blogging & More)

Conclusion: It's Time to Get Out There And Take Some Shots!

Preview of "Photography NOW! - The Ultimate Guide to Take STUNNING Photos and Change the Way You See the World"

About the Author

Dedicated to those who love going beyond their own frontiers.

Keep on pushing,

William Wyatt

Introduction
Are You Ready for an Amazing Journey?

Everyone thinks they're a photographer. Everyone thinks that simply by picking up a smartphone camera, snapping some shots on vacation, popping an Instagram filter on them and setting up a Flickr account, they're automatically a photographer.

They aren't. Unless you know about photography, the ins and outs, the form as an art and as a medium for communication, you're just someone who takes photos.

Make no mistake: anyone *can* be a photographer. Some have an innate talent, sure, but anyone can take the time to learn. But learning is essential.

Think of any other art form: painting, illustration, sculpture. Sure, anyone can slop paint on a canvas. But is it always art? Is it always good? Is it always honest?

Photographer sneaks by because everyone has a camera, but to truly understand the medium takes as much time, effort and dedication as any art form.

And it's not just photography as an art, either: this breezy mentality applies also to photojournalists (Twitter has taken care of that) and wedding photographers (who needs one? We've got our friend, she's got a great camera!). With the rise of pro-sumer SLR availability has come a dearth of integrity in the field.

And, really, you know this. You know that what distinguishes professionals from amateurs is not just the hardware—everyone's got that now—but, rather, what one can do with the hardware.

It's about more than just gear. It's about knowledge.

With this book, I want to equip you with the knowledge that it takes to become a professional photographer. I want to help guide you through the maze of amateur theatrics into something real. Any shmoe can buy a Canon EOS 5D Mark III and take shots on automatic, but if you want to really delve into what makes the camera special, you need to understand its points of autofocus, its full frame sensor and its white balance modes. You need to understand what lenses to use and with what filters.

In short: you need to know your camera.

So thanks for picking up this book. I promise that, by the end of it, you'll have not just a solid understanding of cameras from a technical standpoint, but also a solid understanding of photography as an art form—what makes good composition, and what shapes can create pleasing images.

I won't guide you through specific models, because even though I'm writing in 2014, you may be reading in 2015, and a hundred new models may have been released. But we'll touch on a few popular current trends, like digital high dynamic range (HDR) photography and the new wave of mirrorless cameras, which should give you a sense of what's going on in the industry.

And even if, by the end of this book, you're still grasping at some of the concepts, don't worry: you can always look up terms on Google for more detailed explanations, videos and walkthroughs. This is, after all, a crash course.

So, let's get crashing.

Chapter 1
A Brief History of Digital Photography

Any good crash course ought to start at the very beginning—the beginning not only of good digital photography sense, but of digital photography itself. Don't worry, we won't spend too long on this chapter, but it might give you a deeper appreciation for the art form, its capabilities and just how far its come in a relatively short span of time—in fact, proper digital cameras as we know them were only introduced in the mid- to late-1990s, a far cry from their humble beginnings in the late '70s.

The first true prototype began with Kodak, engineered by a man named Steven Sasson in 1975. Sasson grabbed a Kodak movie-camera lens and combined it with some CCD sensors and Motorola phone parts to create something the size of a small toaster oven and weighed about as much as a large newborn baby.

Sasson's prototype could capture black-and-white images on a clunky old cassette tape, but the resolution of 0.1 megapixels was literally unheard of. The first photograph reportedly took 23 seconds to record, to give a sense of how far technology as come.

Of course, Kodak—which would soon fall behind in the digital photography game—didn't capitalize on this early technological feat. Kodak stuck with film all the way, and it would come back to haunt them three decades later.

A few more filmless cameras went through experimentation phases throughout the 1970s, but nothing took off commercially until 1981, when Sony launched a magnetic video camera—the Mavica. An analogue counterpart to film, the Mavica operated on AA batteries, and stored photos on giant floppy disks that could store up to 50 photographs. The light sensitivity was roughly equivalent to ISO 200, and the shutter speed fixed at 1/60th of a second.

The Mavica launched a brief period of analogue creativity in the camera world, which was followed up by Canon to only some success. In general, analogue cameras cost much more than their quality attested to, though photojournalists put them to good use during major events like the 1984 Olympics, and late-decade events like Beijing's Tiananmen Square protests and the Gulf War. For standard commercial users, paying $1,500 for poor quality didn't make sense.

After the first "true" digital camera was produced in 1981 by scientists at the University of Calgary in Alberta, Canada (it was produced mainly for night sky and space photography), Canon took the helm by commissioning a proper digital camera in 1983, though it never went beyond trade shows—presumably, it was either too expensive, not user-friendly enough or too clunky to ship.

Either way, it would be nearly another decade before digital cameras actually hit retail stores in 1990. It was called the Dycam Model 1, and used a CCD sensor to record pictures digitally and upload them directly to a connected PC.

That same year, a pre-Adobe version of Photoshop was launched, roughly around the same time some entrepreneurs began attaching digital backs to film single-lens reflex cameras (SLRs). The digital revolution, though still in its infancy, had begun to fully take shape.

In the early 1990s, every major tech company joined the fray with more devotion. Kodak launched a camera called the DCS 200 with a built-in hard drive, while Nikon's N8008s offered images in both color and black and white. Apple even ventured forward with something called the QuickTake, a collaboration with Kodak (and later Fuji) that was the first digital camera for under $1,000, but which did not take off.

CompactFlash cards, those large chunky cards that even Canon digital Rebel SLRs stuck with up until very recently, were introduced in the mid-'90s, with Kodak once again helming the tech charge with its innovative built-in CompactFlash technology in 1996.

But 1995 was the true year for digital camera innovation.

But it wasn't until Casio ventured forward that compact cameras became truly, well, compact. Casio's QV-10, released in 1995, offered a 1.8-inch LCD screen on the back and a pivoting lens. It still used a CCD sensor and stored up to just under 100 color images, but introduced the world to features like the macro preset, auto-exposure and a self-timer.

This was also around the time that movie and sound capabilities entered the picture, bumping up the cost of a standard compact from $1,000 to $1,500. Webcams, too, became commercially viable in 1995, with Logitech spearheading the territory with its VideoMan product.

Canon's now-infamous PowerShot series took flight shortly after all this technology was introduced in 1996. It boasted a larger CCD sensor than most others before it (832x608 pixels), as well as camera mainstays like a built-in flash and optical viewfinder, not to mention auto-white balance and an LCD screen on the back. In other words: it was what we understand today to be what a digital camera. Canon also figured out how to drive costs down, so they could charge a cool $949 at the start.

Since then, Nikon's CoolPix and Sony's CyberShot series became serious contendors, while Fuji, Olympus, Kodak, Casio and Panasonic would rise and fall to varying degrees throughout the next two decades. But commercial digital photography—the basics of it—is not even 20 years old, as of this time of writing (in 2014).

That means that everything in the last two decades—every digital SLR, mirrorless camera, phone cam, filter and app—all came flooding in a very small span of time.

We can then understand digital photography as a recent art—even though photography is a much older one, the ability to produce magical digital artscapes, put images into Photoshop and play around, and combine exposures quickly with methods like multiple digital exposure and HDR, are all relatively new experiments.

Digital photographers are still figuring this game out. Even the best in the business haven't been doing it as long as you've been alive. That gives you an advantage, really: even if you're just starting out in the world of digital photographic art, you're not nearly as far back as you think.

To take good photos, you need to understand good camera gear. Even if you're not using an industry-standard kit at the top of the line, you've got to understand what distinguishes a good digital SLR from a great one.

While it's true that no amount of technical knowledge can match up to natural ability, the opposite also holds true—no amount of raw talent can teach you the fundamentals of what is, at its core, a very technical art form. Even if you plan on breaking the rules, it's imperative to at least know them first.

In order to properly control what's in your foreground, background and center, you'll need a basic grasp of how the manual functions of an SLR work. It's not too hard—we'll go through it here.

Appreciating Aperture

Aperture confuses a lot of beginners because there are so many phrases that ultimately refer to the same thing: aperture, f-stop and depth of field are all pretty much synonymous, and that's not obvious to a beginner photographer.

Here's how it works: you adjust your **f-stop** to control your **aperture**, which affects your **depth of field**. So, on a purely technical level, you're only really dealing with f-stops on the screen of a camera.

Think of **f-stops** as the tool, like a hammer and nails, that controls your **aperture**, which is your building material, like wood. When you use your tool to physically manipulate something, the ultimate result is the product—metaphorically, a house; photographically, the **depth of field**.

Starting With F-Stops

On most lenses, f-stops generally range from 4.5 to 8 or so, but various lenses will emphasize low-light conditions, offering f-stops as low as 0.5 or 1.2.

Still following? Good. But your next question might be, "What does all of this mean?" It helps to work backwards.

F-stops ultimately control your shot's **depth of field**, which is itself measured as "shallow" or "deep". A deep depth of field means everything will be more in focus—including the background and foreground almost equally. A shallow depth of field means that your subject will be in focus, but your background won't be; this is what's

called "bokeh", when the background of an image is gently blurred. The quality of many high-end lenses is determined by the quality of their bokeh.

It helps to think of this one, visually, as a standard school ruler, from one inch to 12 inches. Focal length refers to what's actually in focus. If your depth of field is shallow and your focus is two inches away, whatever's sitting at six inches and beyond won't be in focus. But if it's a deep focal length, you can range what's in focus from two until maybe eight inches.

The wider your aperture, the shallower your depth of field—f/1.2, for example, is a very wide aperture, so your camera lens will be big and open, also letting in a lot of light. You'll have to fiddle with your ISO and shutter speed to find a balance so the shot isn't overexposed. (We'll deal with overexposure soon—for now, know that it just means "too bright.")

If you want a deeper depth of field, you'll need a narrower aperture—something like f/16, which will create a consistently detailed image.

When to Shoot Shallow, and When to Wade in Deep

Typically, when capturing cities and landscapes, deeper depths of field are more desirable, so every detail of the frame appears in focus. This calls for a narrow aperture, or *high* f-stop.

A standard f-stop is f/8, which has birthed a classic photojournalism maxim: "f/8 and be there." It means that, as long as your camera's set to f/8, all you need to do is show up to the scene and your shots will turn out, at the very least, decently.

If it sounds like an oversimplification, you might be underestimating the importance of aperture. When you see a rich landscape photo, you need everything to be in focus. Some professional landscape photographers will leave their digital cameras on "aperture priority" mode—that allows you to control the aperture only, and adjusts the shutter speed and ISO based around that. This is ideal because aperture is the most important part of landscape photography for most shooters—otherwise, even if the shot is framed and lit beautifully, if the foreground trees are in focus and the background mountain isn't, the shot is irreparably ruined. You can fix lighting in Photoshop, but you can't fix focus.

Portraits are another form of photography that demand crucial attention to depth of field, but in a different way: rather than in landscapes, where everything should be in focus (that's a *deep* depth of field), it's better for portraits to have a *shallow* depth of field—that way, your subject will be in crisp focus, while the background will be gently blurred. If the bokeh is smooth enough, the portrait will strongly emphasize the foreground and allow the viewer to pay attention to what's important.

Macro shots, like super-close-ups portraits of flowers and insects, are also aided by shallow depths of field for the same reason. If you're shooting a flower close up and there's a bug flying in the background, you might not want your audience to notice it— you'll want the flower to pop out of the foreground.

Other types of photography, like wildlife and sports photography, won't be as affected by your chosen aperture. In those cases, because *movement* is the key aspect to control, shutter speed is much more dominant.

And if you're not clear on what exactly shutter speed is, well—you're in luck.

Setting the Shutter Speed

A camera **shutter** is the photographic term for the part of the lens that opens and shuts, so the **image sensor** can actually see the picture you want to take. **Shutter speed**, then, is the length of time that the shutter stays open for.

If you're working without a tripod, just holding the camera in your hands and pushing down the shutter button rather than using a remote, your shutter speed will commonly range from 1/100th to 1/500th of a second.

The fractions in these numbers can be confusing, and camera newbies just starting out often get the system backwards, because they see the "500" and assume that's a larger number than "100".

In fact, 1" represents one second, and 1/500" is one five-hundredth of a second— meaning 1/100 is a longer exposure than 1/500. A very long shutter speed would be anything from 1" to 30", which you'd only use if you had a tripod, probably shooting at night, and were wanting to achieve an extremely fluid and surreal effect.

But I'm getting ahead of myself. Beyond the numbers, shutter speed is actually a pretty easy concept. The longer your shutter is open, the more light and potential motion your photo is exposed to. This is great at night, when there isn't a lot of light and you want to let as much in as possible—you can turn a sliver of moonlight into a mystical blaze. But you'll need a tripod or sturdy surface, not to mention a remote control, because your hand probably won't be able to keep the image steady for the full time, and even just pressing the shutter button down with your finger will cause it to shake around.

During any shutter speed longer than 1/60, shooting without a tripod and remote is risky, because the shutter will record every shake and gesture your hand makes, no matter how subtle. Using a flash can help, but if you're in a dark space where you can't move around that much—like a concert or even just in a crowd at a festival at night, where you can't hold still very easily—it's easier to rely on other factors to brighten up the image, like aperture and ISO. (We'll get to that one in a minute.)

Still grappling with the concept of shutter speed? Here's a visual metaphor for you: Think of your camera as tightly sealed box, and light as a gas. If you open the box for 1/800th of a second, you'll barely let in any gas. If you leave you box open for 1/100ths of a second, you'll let in way more gas—eight times as much. If you leave your box open for two full seconds, your box will probably fill up with gas entirely.

Remember, here the gas is light and what comes inside the camera-box is the image you'll ultimately produce. The more gas, the lighter the image, and the more stable it will have to be.

Different Shutters for Different Scenarios

Shutter speed gives you a lot of room to move around as a photographer. Landscape and cityscape photographers won't often adjust the shutter speed, because they might leave their cameras on Aperture Priority mode. The only time you might adjust the shutter speed is if you want a long exposure shot of something—this is extremely common with water-based shots, like shots of waterfalls and rivers. The opposite effect—stopping a waterfall in its tracks, so you're able to spy every last splashing drop—would require an extremely quick shutter speed, like 1/1000.

That said, for landscape and cityscape photography, it's often better to worry about shutter speed when you're shooting without a tripod or if you want to blur the motion of something. For faster shutter speeds, lower the f-stop. For slower shutter speeds, widen the f-stop.

When shooting still shots, like portraits and architecture shots, shutter speed matters less, unless, again, you want to blur the motion surrounding the object itself. Often, a simply shutter of 1/200 or 1/160 would be fine.

When you're shooting quick movements, like sports or concerts or even kids running around at a birthday party, a quicker shutter speed is essential, or else everything in the shot will be in focus except the kid himself—he'll be a moving blur of fog, like a ghost.

A Quick Note on Blurred Images vs. Image Stabilization

Some people mistake what motion blur is, or how it's caused. Motion blur has nothing to do with Image Stabilization—that, often shortened to IS, deals with the movement of the lens itself, caused by the inevitable shaking that comes with holding out a long object. When you try to capture a running child and you use image stabilization, you won't notice a difference; the kid will be a blur. The only way to capture the kid crisply in motion is with shutter speed.

Isolate Your ISO

The last major photo factor is ISO speed. This controls how sensitive your camera sensor is to light. It is a crucial control to image quality and is very important to understand for variable lighting conditions.

The most important thing to know about ISO is that raising it causes "noise" to creep into your images—the higher the ISO, the more noise in your images. Noise is the digital equal of film grain and essentially lowers the quality of your images. In your image, noise will be the visibility of what are essentially tiny little colored dots.

When shooting outdoor architecture and landscapes during the day, it's easiest to leave your camera on the lowest ISO possible. In direct sunlight, that's usually ISO 100, or something around there; some cameras will allow you to go as far down as 50.

When shooting indoors, you'll need a higher ISO—anything higher than 1600 becomes susceptible to noise, though if you're shooting with a really strong camera, you can go up to ISO 6400 without any significant problems. (At a certain price point, the smoothness of a camera's high ISO performance becomes a top selling point.)

But sometimes raising the ISO is necessary even outdoors, too—often in cases where you need a quicker shutter speed, which would otherwise explode the image with brightness. Some examples when raising the ISO can help include:

- If it's unexpectedly dark and you're caught without a tripod, a high ISO—even if it gets a little grainy around 3200 or higher—can be a saving grace, because raising the ISO can help you achieve faster shutter speeds (which would otherwise make the image turn out too dark), so you can take shots handheld without them turning out blurry.
- If you're photographing traffic late at night and you want fewer light streaks from headlights, raising the ISO will allow you to use shorter shutter speeds to sharpen up the image.
- Many outdoor photographers don't like using flashes very much, but even indoors, a high ISO speed can allow you to take photos in dark or indoor conditions where other photographers are using flash.
- If you are in a windy area taking sunset shots, longer shutter speed shots are more susceptible to camera movement from wind even on a tripod, might as well take some shorter shutter speed shots at a higher ISO speed just in case just to make sure you get a sharp one.
- If you are in a busy area of a city and people are bumping into your tripod and the ground might even be shaking, raising the ISO speed in order to use faster shutter speeds can help.

The Delicate Art of Light-play

As you might be able to tell by now, photography is a balancing act—you need to balance the aperture, ISO and shutter speed to achieve a perfect balance of lighting,

while stressing whichever of the three matters most in that situation. The only way to get a good grasp is by playing around with the settings until you figure out which one works best for each scenario.

Balancing Your Whites

Every light is tinted a different color—you just might not be able to see it. You might notice that taking photos on cloudy days produces a bluer tint than normal, or that shooting under a canopy of trees will tinge your whole shot green.

That's called color casting, and it's what happens when light is absorbed by certain colors and bounced back out. Cameras can detect this casting; our eyes can't.

The answer is to tweak your camera's white balance. While every camera comes with an Auto White Balance (AWB) setting, and AWB is often pretty effective, sometimes it misses the mark, or produces a compromised grayish quality. I usually leave my camera on AWB on days with unpredictable weather or simple lighting, but if the weather is consistent, it's best to stick to a single weather pattern.

The Different Types of Lighting

For outdoor shots, white balancing options include daylight, overcast and shade (shadier tends to be bluer), although some cameras offer special presets for snowy scenes and beaches because the whiteness of the sand and snow tend to blind the sensor. There's also a white balance preset for when you use the flash, because a camera flash will also tint a scene towards the yellowish/reddish scale.

Indoors, you'll find two common light bulb options, tungsten (yellowish tint) and fluorescent (greenish/bluish tint).

Auto white balance can often detect these differences pretty well, but if you wanted to color-cast your shot even in normal light, giving it a blue or red tint, it's important to be able to immediately detect how different light settings affect different scenarios.

Setting the Metering Mode

Even when photos look bright, eyeballing a shot can only take you so far. Light, especially for when you're printing photos, should be an objective, scientific measurement. Light meters take care of that.

Metering is the what your camera does when it judges an amount of light to decide on a shutter speed and aperture. Film cameras never had this—photographers needed an external light meter to judge how bright a spot was. Now, every camera has a built-in light meter. (Although professionals still use external meters when precision is key; this

is partly a result of them being stronger and able to detect the strength of light falling on the subject rather than in-camera, and partly an old habit of some film users.)

The Metering Types

The three types of metering are evaluative metering (a Canon term; Nikon users know this as "matrix metering"), center-weighted metering and partial metering, a variant of spot metering.

Evaluative (or, again, also called matrix) metering is the common one. Many photographers of all stripes leave their cameras on evaluative, and you likely will also. Evaluative metering casts a wide net of potential lighting options and segments them into zones, after which it finds your focal point and measures the light of the entire frame based on that, often accurately.

Center-weighted metering does what it sounds like: it weighs the center of the frame as what should be most in the light, and disregards the surrounding image.

Spot metering, conversely, does the same but with a smaller portion of the center frame, usually just a small spot in the center of it. This makes it easier to capture non-moving objects, when you have time to set up the shot.

Partial metering is similar to spot metering but acts a little bit more broadly. It's easier to set up shots quickly, but would also be best for backlit photos—say, someone standing against a sunset. You'll have to frame your image carefully, but they're better options for when you want to ensure that a centerpiece is lit up, regardless of the surrounding imagery.

Stay Focused—How and When to Use Manual or Automatic Focus

It takes years of shooting to train your eye to identify what's in focus versus what isn't. As a result, most photographers just starting out tend to leave the focus on automatic and not worry about managing it.

But autofocus isn't perfect. A lot of times, autofocus has no way of knowing what you want to focus on. If you're shooting a flower in front of a mountain range with a very shallow depth of field, you might want to focus on the flower, but your camera might easily assume you want the mountain in focus.

There are three preset ways to control autofocus: all points focus, flexible focus (also known as multi-point) and center point focus.

Center point focus is the most common, and the one photos use the most. It means you've got to first center your image, then press the shutter down halfway to lock whatever's in the center of the frame in focus. After that, as long as you don't take any

steps forward or back, you can adjust your camera around to arrange the composition however you like.

All points focus is useful for moving objects—animals, sports, or anything that would make it impossible to center and set up a composition. In landscape and cityscape photography, this isn't as common, but it's good to use if you want to snap any street shots or animals while you're out on a shoot.

Flexible focus is a hybrid of the two, wherein you're letting your camera decide which of the focal styles to use—a centered style or a multi-point one. This would be useful if you're not sure what you're going to find in a landscape shot, and you want to be prepared for anything.

Focusing in Low Light: An Invaluable Trick!

Auto-focusing at night is extremely difficult, because cameras can only focus properly in bright light. (That's why flashes are necessary.)

One way to ensure a tight focus at night, or any time your autofocus is on the fritz, is to switch to manual focus mode and turn on your camera's Live View screen option. Zoom all the way into a shot using the screen and focus it that way—as long as the edges are sharp, once you zoom back out, it will stay that way.

Long Exposure Blurs? Ditch the Image Stabilization

When it comes to long exposure shots, image stabilization may be your worst enemy. The problem happens when the IS motor will suddenly detect its own vibrations, causing the tripod to shift and subtly amplify the movements. The quality of tripod or camera doesn't matter—it's just a weird glitch in the physics of digital photography.

The end result will be fuzzy, but you can solve the problem by turning off IS on long exposures—which you don't even need anyway, since you're using a tripod.

The DL on RAW vs. JPEG

Before you even begin to set up a shot, you'll have two output shooting options: do you want your files to be in RAW or JPEG?

The answer is RAW. It's pretty definitive, actually, if you're trying to be a professional at all. (Or even aiming for professional-grade photos for fun.)

The difference is simple: RAW files are enormous and richly detailed; JPEGs are smaller and quicker to work with. JPEGS are fine if all you want is to upload shots directly onto

Facebook, but if you're planning on doing any post-production in Lightroom or Photoshop, RAW is the way to go.

I used to use JPEGs because they were smaller and uploaded faster to my computer, but the advantages of RAW outweigh that too much. On a single exposure, a RAW file produces a much more flexible ground from which you can edit color, contrast and light.

RAW is the preferred format for professional photographers of any style, but it's especially useful for landscape, cityscape and architecture photographers who want to make large prints. That's because RAW files are much more technically complex and rich: they're 12- or 14-bits instead of JPEG's 8, which encompasses over 4,000 color shades—significantly more than 8-bit shots' 256 colors.

When editing a colorfully rich landscape shot, you want a bit of leeway when it comes to post-production. Adjusting levels in a RAW file makes for a much smoother, more natural editing process than when the actual composition of the photo is smaller and rougher.

Stay Safe: Bracket Your Exposures

Exposure bracketing is kind of a luxury. If you have the time for it, it can save you a tremendous amount of pain and time spent digital retouching after the fact.

Exposure bracketing does what it sounds like it does: it means you're bracketing your shot with two others, one over-exposed and one under-exposed. The idea is a safeguard and can also prep you for a high dynamic range image if you decide to go that route in post-processing. You're protecting yourself against your camera's auto-exposure settings.

The idea is that your camera's light meter, if you let it automatically select an aperture and shutter speed, might get the light wrong—it could see a skier standing in a field of snow and exposure the shot so the snow doesn't seem so blindingly bright, which in turn transforms the skier into a shadow. The opposite may also be true, and your light meter may incorrectly assume a shot is too dark when it's exposed the way you want it to be.

And what if the shot is a one-of-a-kind opportunity? You can't risk over- or under-exposing your shot, so you'd bracket it between two safety shots: one possibly over-exposed, and one possibly under. For really great shots I often blend the best attributes of each of the bracketed shots together for a high dynamic range image so everything in the photo is perfectly exposed.

For standard shots of landscapes, portraits, architecture and sports, the industry standard is to take three bracketed shots (-1, 0, +1).

When dealing with vastly varying light degrees, it's nice to bump that number up to five shots, with two brackets on either side (-2, -1, 0, +1, +2). Because cities tend to offer a lot more light spots and dark spots—especially at night, when shadows and bright lights contrast in swirls—it's good to have the balance available to you, especially when bringing the shot into post-production.

Usually, if the original shot is good enough, photographers can work with that alone in Lightroom or Photoshop and not bother with the bracketed ones. This isn't always the case, which is why it's good to have a backup—you can never really tell until you upload them on your computer afterwards. I sometimes find myself processing one of the higher exposed bracketed shots instead of the primary exposure because the extra light often makes the final result more dramatic.

But, like I said at the beginning: exposure bracketing is a luxury. If you've got the time for it, it's nice; if you're on a brisk schedule or can't stop every time, though, it's fine to just take one or two shots and not worry about setting up your tripod to take multiple exposures every time.

Use That Self-Timer

Typically, when we think of using the self-timer, we think of family gatherings where one guy sets up the shot, sets the timer to five seconds and rushes into the frame with only a second to spare.

But professionals can use the self-timer also, and not just for self-portraits. The benefit is that the self-timer takes a shot regardless of whether you're pushing a button—and, when it comes to things like long exposures or bracketed shots on tripods, you need the shots to be identical and unmoving.

Try setting up a shot with a two-second self-timer to avoid any motion blur from your finger touching the shutter. This technique is also useful for handheld HDR shots during the day or dusk, because the self-timer can be set up to take multiple shots in a row. Again, bypassing any possible motion blur is a huge benefit here—whenever you can avoid touching the camera to take a shot, it helps.

The Bare Necessities

That's all for this chapter! It might seem like a lot, but in truth, it will all become second nature soon enough. The trick is to get out there and shoot, shoot, shoot as much as you can, and the natural knowledge that will flow from that will soon become secondhand.

Don't be intimidated if you don't understand certain aspects yet—if you're ever in need of more clarification, turn to a photographer friend or go online to messages boards

with questions. People are generally helpful and kind to newcomers with courteous, honest questions.

Chapter 3
The Big Guide to Camera Gear (Here's All You Need...)

A true professional photographer isn't inhibited by their equipment. I'll use a digital SLR when I can, obviously, but if there's a gorgeous, spontaneous photo op and all I have is my iPhone, I won't hesitate to capture the moment.

The trick to good photography is in seeing the world as a series of potential photographs, as seeing the art in everyday imagery. It's all in the angles and lighting. Once you're able to do that, you can capture any moment somehow—even if it's not what you have in mind, you can capture a shot as well as anyone could.

In this section, we'll go through some of the main gear expectations most professional photographers deal with. Don't feel obligated to buy all of it, especially all at once; your gear will be an ever-evolving stream of equipment that you'll buy, sell and upgrade over years and years. But it's important to know what's out there.

The Myth of Megapixels

There are a lot of technical specs to sift through when buying a new camera body. Before we get into the exact types, there's one myth we need to dispel first: the myth of megapixels.

Professional photographers know that megapixels aren't nearly as important as consumers are led to believe. Image sensors and low-light performance are much more crucial factors when choosing new gear.

The biggest reason to pay attention to megapixels is that a higher megapixel count will increase the image's resolution—meaning the image itself will be larger. This is especially useful if you shoot wide but plan to crop in later.

Digital SLRs

Digital SLRs are the product of choice for professional photographers. SLR stands for Single Lens Reflex, which essentially means you can detach the lens and screw on a different one. This is what distinguishes SLR cameras from compacts—an SLR is much bigger and heavier, and offers photographers much more leeway and variety in what kind of shots they can take.

When it comes to choosing a DSLR, there's no right or wrong decision. It depends entirely on your own personal preferences.

The two giants of the DSLR world have long been Canon and Nikon. In the world of entry-level DSLRs, The rule of thumb is that Canons generally skew towards lighter,

plastic bodies and user-friendly interfaces, whereas Nikons are heavier and sturdier, built with more metal parts and an appeal towards a certain devoted crowd. I personally shoot with a Canon, but mostly because I started out with a Canon Rebel, and began investing in Canon gear from there. Today I shoot with a Canon 5D Mark III, but I defy you to figure out which of my shots came from the Rebel and which from the 5D.

Sony is something of a newcomer to the DSLR world, but is rapidly becoming a strong contender in the market with quick speeds and small, light bodies. Many will swear by them for their commitment to the German lens manufacturer Carl Zeiss; others find that Sony cameras feel like plastic toys, are far too light and counter-intuitive. It's an ongoing debate. Olympus, too, is a unique camera company in that its DSLRs tend to gear towards niche photographers and hybrid camera models.

Full-frame or cropped sensor?

Camera models come with sensors cropped to various sizes. The sensor is the part inside the camera that actually captures the light of the image. When a sensor is "full sized," it means that what you see through the viewfinder is what you'll get—the final product won't be cropped at all.

Cropped sensors are more common in less expensive Digital SLRs. Cropped can mean a few things, but it usually images the image is being cropped anywhere from 10–25 percent. So even though you see a full image in your viewfinder, the edges will be cut out when you view the file after capture.

The basic benefits of each are clear: full frame cameras are more expensive than cropped frame cameras, not to mention being larger and heavier. If you're buying a full frame camera, you're making a big investment.

But the benefits are myriad beyond just that one simple fact. A full frame camera is a great investment for any photographers, whether he or she is shooting

Here are some other features you should look for in a DSLR:

Mirror lockup

SLRs offer what's called a mirror lock-up, or MLU. This locks the camera's internal mirror in the "up" position before the shutter is pressed, which noticeably reduces the amount of movement in the camera itself.

Basically, just by taking a picture, a digital camera will vibrate. When we think of shakiness in a picture, we usually associate it with not using a tripod. But even using a tripod and pushing the shutter down with our fingers causes a great deal of blur.

The way to avoid this is with a remote control and tripod set up, but *even this* requires the mirror to snap up, the aperture to open and the shutter curtain to expose the sensor. All those little machinations cause the camera to vibrate all by itself—even without a person touching it.

Mirror lock-up reduces that to the least amount of movement possible, allowing your camera to remain virtually still while snapping shots on a tripod. It's a great tool for long exposure shots and quick multiple bursts.

Exposure Bracketing

These days most DSLRs will have something called AEB—Automatic Exposure Bracketing. With AEB, you can take usually up to three shots with a single press of the shutter, with the two "extra" shots as safeguards for what you believe to be the correctly exposed shot—just in case it isn't. You can adjust the exposure settings of the bracketing shots, too. Bracketing is also an important feature for doing HDR photography.

Some DSLRs are unique in that they offer AEBs that snap up to five bracketed shots or more. For cityscape photographers especially, this is a handy tool, due to the wide ranging light intensities from streets and buildings at night.

Live View

When Live View debuted, it was widely seen as a dumbing down of "true photography"—the distinction between DSLRs and compact cameras was always that, to use a "real camera", you had to use the viewfinder.

Since then, Live View has grown into an essential tool for photographers of all stripes. One of my favorite uses is manual focus at night. With so little light, the bright screen is invaluable for zooming in and adjusting the focus at 5x or 10x magnification. It's like having a 10x loupe magnifier built into your camera.

Some cameras now have tilting screens, too, which are useful for awkward angles that render the viewfinder useless. Abnormally high or low angles are ideal for popping out the screen to look at it from wherever you're standing.

High ISO Image Quality

A great determiner of digital camera quality has always been high ISO performance. Low-quality cameras are marked by their noise—the grainy quality images suffer from when taken in extremely dark light with a high ISO like 3200 or 6400.

Stronger cameras with stronger sensors will overcome this noise problem with crisp high-ISO performance and low grain. When flash and tripods aren't viable options (like at some concerts, for example), high ISO is the only option.

Larger sensors, in general, allow for more light to be let in, which create all-around brighter, more focused pictures. If your image does wind up noisier than you'd like, you can also turn your image around and own that style: play with layers and saturation levels in Photoshop and the grain can wind up looking like a more natural filter.

Beyond the SLR: Looking Into the Mirrorless

Arguably the biggest recent impact on digital photography has been the production of mirrorless cameras. A mirrorless camera produces the same image quality as a DSLR, but within a fraction of the weight and size.

They can afford this by removing the mirror from digital SLRs—the thing that we discussed above, which is a remnant of film SLRs and takes up as much bulky space as the sensor itself. In this way, mirrorless cameras are the way high-end digital cameras *should* be made—as small as possible to be more efficiently created.

The pros of mirrorless cameras are obvious: the size and weight make traveling a breeze unlike ever before. They are also, in theory, cheaper to make, because they use so many fewer mechanical parts. Such fewer parts also mean that there are fewer opportunities for vibration—no mirror means no need for Mirror Lock-Up, and less noise to boot.

But the mirrorless models are new, and the product still has some kinks to iron out. The biggest one is battery life—between the smaller battery and constant live view, the most common complain across the board for mirrorless cameras has been about how quickly the battery dies.

The second most common complaint is about that little thing I just mentioned, the constant live view; another casualty of downsizing the DSLR has been the optical viewfinder. Many mirrorless cameras don't have one, so while the LCD screens on the backs of such models have been brighter, seeing them clearly in sunlight is still a trial, and they use up more battery life whether you like it or not. Some models offer electronic viewfinders, which suffer from a slow lag response or high-contrast manipulation (to ensure visibility, but not accuracy of color).

There are a few more pros and cons to each, including autofocus system and sensor size, but fans of each will point out cons of the other. The biggest definitions are stylistic ones: do you want a camera that's smaller and easier, or bigger and occasionally more able? Neither choice is wrong.

Through the Looking Glass: Choosing Lenses

It's hard to overstate the importance of a good lens. If bodies are the meat, these guys are the potatoes. More than Photoshop savvy or add-ons like flashes and remotes—heck, more than *the camera body itself*—good glass is often the biggest difference between a crisp shot and a blurry one. And their costs reflect that.

The good news is that lenses can last forever. Even despite a lack of autofocus or image stabilization, many old-school photographers still use their film SLR lenses on digital bodies. That's because lenses don't age the way camera technology does—a good lens can be locked onto any body, which is why many photographers who start off with Canon (like I did) wind up sticking with the brand their whole careers, because that's what all their lenses belong to.

If you're unfamiliar with lens focal lengths, a quick and terribly simple rundown: the smaller first number is the widest and farthest-back angle, while the larger number is how far you can zoom. A standard kit lens will be 18-55mm. In a standard lens range, anything less than 18 is considered quite wide, while anything larger than 300 is a strong zoom. There are bigger extremes on both ends.

To use myself as an example, my primary lens is a 24-105mm. I like it for flexibility, and though it's not as wide as I like to get when shooting landscapes, it covers a good range in a relatively tight package. If I carry a second lens for a landscape/cityscape shoot, it would be to complement my 24-105—I recently picked up a Canon EF 16-35, which is a great wide-angle lens and yields even better results in landscapes and cityscapes, but useless for zooms.

There are five general focal length ranges for lenses, each with a different purpose:

We'll start with **ultra-wide-angle** lenses. Usually between 12-18mm, these are ideal for vast, expansive landscape shots, but they give a different sense than you'd think—because of the amount of peripheral vision they offer, they're the closest thing cameras can come to replicating human eyesight. That means that when we see an ultra-wide shot, we feel immersed in it. Get close to objects rather than standing far away. Many photojournalists use ultra-wides to get up close to subjects and snap a portrait while still grabbing a lot of surrounding context: they'll stretch out nearby objects and distort depth of field, but without technically distorting the image—unlike a fisheye lens, which offers an equally wide angle but with unrealistic curvature.

The next tier of lens would be the **wide-angle** lens, with a 20-35mm range. These will come a good deal cheaper than ultra-wides on average, so if you're a beginner, you're more likely to be grabbing one of these. But they are still terrific for all-encompassing landscape shots. They're often light, small and heavy-duty enough to endure trekking a mountain to grab a heavenly sunset snapshot. Whether you're standing far away for a wide vantage point or want to play with foreground/background sizes, you'll definitely need a wide-angle in your gear bag.

In the 50mm range, there are a large number of fixed **prime lenses** that usually stick around 50mm and offer a much faster aperture. The f-stops on these lenses can go as low down as 0.5, though for even just $100 Canon sells a prime lens with an f-stop of 1.8 that's great for portraits and close-ups.

If you want a bit more versatility in a single lens, a **mid-range zoom** is a good bet. With an average of 24-70mm reach and often pretty fast apertures of around f/2.4, they encompass the breadth of standard fast prime lenses (like 50mm fixed lenses) and offer something a bit more extensive than the standard 18-55mm kit lens. A lot of photographers say to skip the mid-range zoom, since it's neither a strong zoom nor a strong wide-angle, but when you're shooting landscapes and don't want to lug around a lot of gear, simplifying can be great for saving time, not to mention space and weight in your bag.

If you plan on shooting subjects from far away—across cliffs or from building tops—you'll likely want a **telephoto zoom** lens, something between 70-300mm. I rarely carry one around because I usually am looking for wide angles in landscapes—which this is definitely not. Nevertheless, they're incredibly useful for grabbing faraway details like flowers, people or statues that I wouldn't normally see otherwise.

Lastly, there's the titanic **super telephoto** lenses, 400-800mm. These guys are hefty, expensive beasts that will certainly double (if not triple) the cost of your entire pre-existing camera gear. I tried a friend's once for fun but haven't needed one ever since; they're common for sports or wildlife photographers who want to grab quick close ups from the sidelines. Otherwise, the fact that 400mm is its widest setting makes them incredibly restrictive for landscape photography, and frankly a burden to lug around and switch on and off your camera body.

Lens Verdict

There are more options, also: when I travel, I like to keep my kit light and use a single 18-200mm lens to encompass everything from a wide-angle to a decent zoom. I'll sometimes bring a 50mm prime lens along for the ride if I want a balance with a focus on depth of field, but if I need a single lens, I'd prefer variety to lugging around more weight.

The problem with the 18-200 solution is that, when you pack so much depth of glass into a single lens, you're bound to find some distortion at either extreme (the 18 and the 200mm). This is worse in, say, an 18-300 lens, but it's still a big enough problem—combined with the fact that it's less than ideal in low light and colors come out a bit murky sometimes. But, for me, when I'm traveling often and can't deal with the bulk, the pros outweigh the cons—literally.

Otherwise, there is, again, no "right answer" to the lens question—as long as you carry two or three that complement each other, you'll be fine. One ultra-wide, one mid-range and one telephoto would be ideal. If you're a hobbyist, the sky's the limit.

Tripods

Tripods are pretty much essential for most types of photography, including portraiture, landscapes, cities at night and posed scenes.

With all these varieties of photography, tripods are needed because so much of it depends on stillness. This is especially true at night, when long exposures become more than attractive—they become pretty well necessary to see anything at all.

Further, if you plan on exploring the world of HDR photography you will need the camera to remain absolutely still through bracketed shot sequences.

When shooting with a tripod, you want to capitalize on speed where you can. If it takes you a long time setting up your equipment for each photograph, your going to find yourself taking a lot less shots. You're going to want a tripod that's quick to adjust and get situated.

The biggest considerations are weight and sturdiness. For my Canon 5D—one of the heaviest cameras on the market—I use a heavy-duty tripod from Really Right Stuff and an attached L-plate, which is admittedly on the more expensive end of the spectrum, and not necessary for every photographer. I shoot enough landscapes and cityscapes that I felt my career justified the cost.

I didn't start out with that setup, of course. I used to have a smaller travel tripod, the flimsy kind that folded up into a backpack easily. This worked fine to prop up my camera in normal weather conditions. The best factor was that it fit really neatly into my luggage, which is great to avoid checking luggage on planes.

The problem was that, because it was lighter, it was quite vulnerable to motion from the wind and my long-exposure images came out blurry unless the weather cooperated. It also took a lot more time to set up because there were five incremental leg extensions instead of three, which is standard for heavier-duty tripods.

Filter Your World

There's a great deal of debate surrounding whether filters are necessary on every lens in your kit. Some will argue that if you're spending $1,000 on a lens, you ought to protect it—I use a B+W 77mm UV filter to protect mine, which causes little discernible difference in the end result, but simply protects my lenses from getting scratched.

Others will claim that a cheap filter ("cheap" is often classified as "less than $100") will create unwanted flare or mug up the image quality. This is certainly true of some brands: it's best to do research and test out a few filters before purchasing one, if it's just for protection and not any added effect. (UV filters are common for this.)

That said, if you want a filter with some usefulness, there are loads to shop for to benefit your landscape shots. Like I mentioned earlier, neutral density (ND) filters are great for long exposures during daylight hours, because they darken the image enough to balance out the light let in by leaving your shutter open for seconds at a time, allowing you to shoot foggy, dreamlike waterfalls straight out of Narnia.

Another practical filter is a polarizer. These tend to take the harsh edge off bright whites and bring color out of gray areas, but most importantly, they cut reflections out of water and glass—an effect that's technically possible to replicate in Photoshop after the fact, but difficult enough that it's worthwhile just to buy the filter.

A lot of landscape photographers also like to shoot with a graduated density filter. This is similar to neutral density, except instead of covering the entire lens, it creates a gradual effect from neutral density near to the top to normal colorization at the bottom. It's purely for bright landscapes—ideal for when the sky is a harsh brightness, but you don't want to darken the bottom half of the frame along with it.

Common HDR techniques can solve this problem in post-production, but it's usually visible to the naked eye that photos are retouched like that (a subject we'll discuss in greater length in chapter 5); a graduated density filter creates a subtler, more natural image. And besides, like every instance of in-camera-versus-post-production, using a filter often takes way less time.

Final Thoughts

While this list is by no means exhaustive, I hope it offered you some insight into the possibilities of a standard gear set. You won't need to buy everything I mentioned—but it's good to know what exists, because something might pique your interest.

The important thing, above all, is to take good quality shots. Never be dissuaded by the fact that you don't have something you think you need to snap a good image. Try anyway, and experiment away—sometimes, you never know... You might just impress yourself.

Chapter 4
Photos as Art: See the World Through a Photographer's Lens

As a photographer, your eye is your lens. After you start exploring the world with a camera, you'll find that you automatically begin to see things differently: you'll notice more the composition of architecture, or appreciate how the sun is glistening through the trees at the right angle. You might see the framing of the moon through your window as a photographic opportunity.

Photography teaches us to appreciate our world—visually at first, but also emotionally—in a whole new way.

But not everyone is born with a photographer's eye. You should definitely check out more photographs online in your spare time by browsing Flickr or 500px, but you can also hone your eye just by knowing what makes a photograph aesthetically pleasing.

Compose Yourself

Structure is a key component of photography, and art in general. There are a few ways to define structure—generally, it can be defined in terms of color, shape and contrast between lights and textures.

One of the reasons keeping the basics of photo structure in mind matters is so that, if you do something right, you can keep doing it. There's nothing worse than an aspiring photographer who takes a shot and loves it, but can't articulate why.

You may hear the word "**composition**" a lot when it comes to art. Composition refers, simply, to where things are in the image—whether a head is touching the far end of the frame or in the center of the photograph is a matter of composition.
When composing an image, look for what's striking—a bold color, or a figure sticking out.

Rule Your Thirds

All photographers should be aware of what the rule of thirds is, so they can use it if they choose. This rule should be viewed as totally optional, but it is a valuable guide to creating visually pleasing and well-balanced images.

One of the oldest concepts in art—not just photography, but all of art itself—is the rule of thirds. If you're unfamiliar with this rule, it simply states that images look nice when they're divided into threes. Imagine a tic-tac-toe grid overlaying your image: three lines up and down, three downs left-to-right.

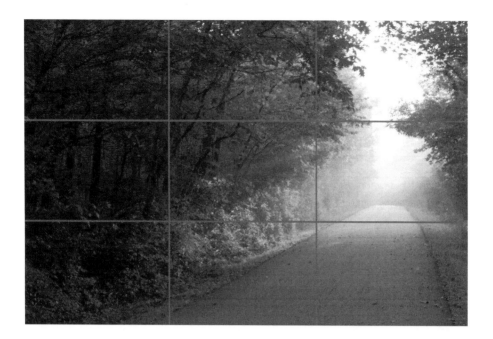

Consider almost any shot of a mountain: sky fills the top third, the mountain range is in the middle, and there's a good deal of grass or a valley beneath that. Three big areas, three sections of the frame.

The "third position" is the intersection of this tic-tac-toe board. There are four thirds positions, making up the points of the rectangle in the middle of the frame.

If you're working with any particular subject, try popping it into the thirds position instead of the middle. Symmetry works sometimes, but shooting off-center gives off a feeling of movement and fluidity. If you're focusing on a tree in the woods, rather than framing it centrally, try placing it in the left or right third of the frame. You'll notice the difference: rather than looking static and square, your shot will look more appealing.

Why cut them into thirds?

Images divided into third exude an inexplicably peaceful vibe. They feel comforting to look at, like they're naturally meant to be that way.

Some believe the rule of thirds is a spinoff from a famous mathematical sequence known as the Golden Mean, Divine Ratio or Fibonacci Sequence. Not to get too technical, the sequence (developed in 1200 A.D. by Leonardo

Fibonacci) means that you start with 0 and 1, and add the last two numbers in the sequence together. Like this:

0, 1, 1, 2, 3, 5, 8...

(Explanation: 0+1 = 1, 1+1 = 2, 1+2 = 3, 2+3=5, 3+5=8...)

...And so forth. But how do we visualize it? The answer comes from the difference between the numbers: the next number in the sequence is roughly 1.618 times the previous one. In mathematics, 1.618 is known as "phi".

Visually, this means the frame is repeatedly divided into 1.618, with arches connecting one corner of a square or rectangle to the next.

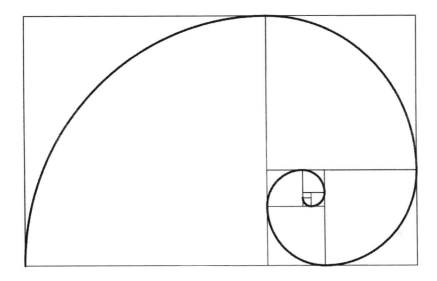

This becomes an ongoing spiral, and is a more technical version of the rule of thirds that painters, designers and illustrators have been using for centuries. It creates a natural sense of flow in the direction of the spiral—no matter where on the frame it sits, the focal point will lie on a corner two-thirds across the frame, and if you place your subject there (a mountain, tree, etc.), it's almost guaranteed to give a pleasing feeling to the eye.

This rule doesn't always hold true, of course. The rule of thirds is one of the best (and easiest) to break. Perfect symmetry works nicely as well, and playing with natural borders as frames can lead to really interesting results, too. But it's a good standard rule to keep in mind when out in the field, if you're stumped for an interesting shot and need to get something basic and workable.

Lead Those Lines

Whether you realize it or not, we look for closure in art. Faces are jarring when they're cut off at the forehead; something's off when we see a woman, pictured at the left-hand side of a frame, looking left instead of right. Certain images are more pleasing to the eye than others.

It's our job, as photographers, to know what designs work—what lines and circles automatically soothe our minds—and find them in the real world.

One great way to find closure in ever-expanding landscapes is to look for leading lines. Leading lines are self-explanatory: they lead our eyes, usually from somewhere in the bottom of the frame to somewhere in the top third, or from one side of the frame to another.

Leading lines don't have to be straight, either. They can curve and twist from one corner to another. But there should be a sense of oppositeness—if you're starting in the bottom-right, you should end in the top-left. You want to take your viewer on a small journey within the photograph.

You should look for lines in nature and manipulate them to indicate a certain emotion or story. If you stumble upon a barren path in the woods, you might want to show as much of the emptiness as possible to show a sense of rustic desolation.

Leading lines are great for a few things:

- Perspective - what looks big, and what looks small?
- Depth - make your canvas look larger with a shallow depth of field
- Conflict - do your lines intersect?
- Grandeur - is someone or something standing at the end of the road?
- Infinity - if your lines circle inside the frame, what visual effect does it create?

You won't always find lines in every shot. You've got to know how to look for them, and how to shoot them.

When you see a tree and want to show its size, get right up next to it and point up. When you want to show a river streaming down from a mountain, try carefully stepping into the river to shoot down along with it. To capture a grandiose valley, get as much of the length as you can—don't just settle for a snippet, but find and angle that shows how it snakes through the mountains.

When you look for leading lines, you can find them everywhere. Even if they're subtle, they can add more depth to your shot than any lens could.

Finding Natural Frames

Just like a photo frame can pull together a printed photograph, a natural frame inside the image itself adds dimension and closure.

When we talk about natural frames, we talk about anything in nature that creates a frame within the shot—vines, branches and trees are typical; rivers or streams sometimes work; if a mountain range splits in the middle, shots can sometimes be framed even between two peaks.

Framing a shot is as easy as finding lines and curves that shoot around your focal point. If you're shooting a mountain and standing next to a tree, take a step back and try to incorporate the tree into the foreground, its trunk and branches creating a partial frame on the sides and top.

Be careful when hunting for natural frames—don't force your image to fit a certain composition when it just isn't there. Choose strong, emphasized lines to your advantage. Try to find lighting and texture differences. Turning a tree with a smattering of branches into a frame for a forest of smattered branches behind it probably won't work as well as, say, a river cutting through the forest on one side and a fallen log on the other.

If you can find a cave to shoot out from, walk inside and look out. The cave will not only give you a natural frame all its own, but also a new perspective: it turns your camera into a character, an animal or caveman, and invites your viewers to see the world through their eyes.

Finding natural frames can force you to create new perspectives. If you find an especially cohesive set of vines or trees from which to shoot between, it creates an almost mystical environment, like the frame always existed, and was just waiting for someone to peak through it.

Don't be Negative About Negative Space

Negative space is a crucial aspect to photographic composition. Often black or white (but not only in black and white images!), negative space is the space not filled by anything—a clear blue sky, or a blank wall. Often it can be a powerful statement on its own, or simply accentuate the subject of the photo, especially if the subject isn't centered.

In photography, contrast refers to the starkness of one color or lightness against another. We might see a lot of darkness set up squat against a high-contrast turn, like a lush green park. It makes the park look inviting and warm, against the cold insides of wherever we are.

A shot of a crying girl in a park is one thing. It tells a story, it's a document. But a shot of a crying girl standing against a blank white wall is something else entirely—rather than tell a documentary story, it tells an emotional one.

Chasing the Golden Hour

Of all 24 hours in a day, only two mean anything to photographers: the hour after sunrise, and the hour before sunset. That's when the sun does its magic, casting a heavenly golden glow over the world, making mountains shine and lakes sparkle beautifully.

Mind you, the word "hour" there is pretty loose. Depending on the time of year and where in the world you are, the golden hour can last anywhere from 20 minutes to well over an hour. If clouds are passing by, the whole thing might only be useful for 10 minutes—that's why the elusive moment is so desirable among professional photographers, and why setting up the right shot in advance is so crucial.

The golden hours are pretty much guaranteed to enhance any landscape shot. They offer a rich natural warmth that's difficult to accurately match in post-production. That said, if you're shooting *into* the sun at this hour—which you might very well be, if you want to capture the purple or orange rays cast over the clouds, or above an ocean—it's a good idea to use exposure bracketing for high dynamic range (HDR), a method of composing multiple exposures in post-production that balance out various conflicting exposures.

Exposure bracketing here is a great idea even if you're not shooting into the sun, because when the golden hour lasts as briefly as it does, you want to guarantee that at least one of your shots turns out great.

If you ever want to shoot directly into the sun, here's a tip: wait for the golden hour. Shooting into the sun can potentially be dangerous to your eyes and damaging to your equipment during regular daylight hours.

That said, using the sun as a backdrop to any landscape or cityscape shot can add loads of drama, great depth of field and sometimes a very cool perspective. If clouds are blocking your gorgeous sunset, use them to your advantage: look for leading lines streaming out from the background. If you're shooting a portrait, rather than using the golden rays as a spotlight, flip your angle and silhouette your subject against the sky.

Depending on your angle, lens and filter, you can also use lens flare to your advantage—something a lot of photographers will add in Photoshop if there isn't any, though it's very tricky, because the wrong angle can throw off the whole shot. As usual, the best way is to find it naturally.

And then, of course, after the sun has set, what's next? It's common for photographers to keep shooting—they know full well that the photography oasis has passed, but they've got everything set up, and the lighting, while visibly darker (in the evening) or harsher (in the morning), is still workable.

What's nice about sunset or sunrise photography after the golden hour is that you've got a much more comfortable window to play around with. You don't want to waste a precious second of that golden moment, but after it's gone, who cares? Immediately post-sunset is a great time to experiment with dark, moody shots: the sky is a deep azure but far from black.

Assuming everything else stays constant, you'll need to lengthen your shutter speed to compensate for the lack of light in the evening. The lack of direct sunlight will actually make balancing the light a bit easier, but exposure bracketing is still a good idea if you want to blend images together and work around difficult exposures.

The hour after sunrise is a bit more difficult, because the sunlight will likely be generic and harsh, casting tough shadows downward. It's still workable, though, and better for shadow control than noontime, so go out and find as many cool angles as you can before 11 o'clock if you're out for the whole morning.

Right Time, Right Place

As Woody Allen once said, "80 percent of life is showing up." The same is true of photography: right time, right place.

As a photographer, you've got to train your eyes to watch for good locations, interesting angles and unique shots. When you see one, you won't always have time to set up your heavy tripod and grab the right lens—you've got to work with what you have, even if it's an iPhone or simple point-and-shoot.

Take a moment to just enjoy the scene and consider the best angle to shoot it—rarely is the best angle where you happen to be standing at that moment. Consider low, high or side angles of any scenario.

When you need to think quickly, it's good to remember the fundamentals of setting up a shot: look for reflections, leading lines and thirds to divide the shot into. But, if you have time, try also breaking those same rules: capture a scene in a unique perspective that

people may never have seen before. Landscape photography is tricky, because there's a great sense of "been there, done that." Get creative—you'll have more fun.

Chapter 5
Tricks of the Trade (Exposure, Lens, HDR)

There are so many tricks to the trade that it would be impossible to mention them all here. Instead, we're going to go through some of the more interesting tricks that you may never have thought to try otherwise.

The goal here isn't to make you a master of every domain, but rather to expose you to every trick available to digital photographers today, and see what sticks. You won't be great at everything—in fact, some styles you may even resent, like shaped bokeh or HDR photography, which many purists scoff at modern photographers' over-reliance on.

But that's fine. Don't listen to them. I want you to shoot the kinds of shots that you think look best—no matter what the others say. And the only way to do that is by experimenting like crazy.

For many of these, you'll need a tripod and a decent understanding of aperture and shutter speed. If those concepts are still a bit fuzzy in your mind, no worries—just head back to chapter 2 of this book and refresh yourself with the terms and definitions laid out there.

Other than that, you should know that these are all techniques that are nearly impossible to replicate in post-production applications like Photoshop. These are all in-camera techniques that many photographers choose to specialize in. If you're ready to take the plunge, then lets get started:

Long Exposure

The first and most common trick is long exposure. For this, you'll need a tripod, and sometimes even a neutral density (ND) filter, depending on what you're shooting.

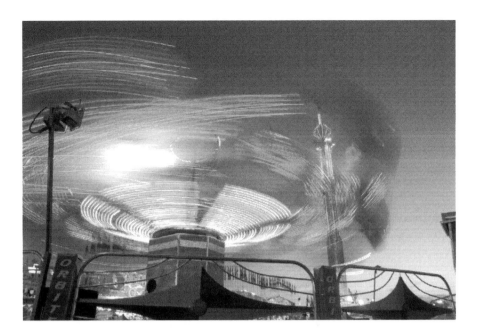

Long exposure shots are exactly what they sound like—they involve leaving the shutter open for an extended period of time, usually a few seconds at least. For that reason, a tripod is imperative for long exposure shots, because any movement at all can cause the camera to shake and your image to be blurry. You should also use the self-timer or a remote cable release to avoid pushing the button on the camera, which causes additional shakiness. As a final touch, turn on the mirror lock-up option in your menu to avoid the minor shakiness that simply opening the mirror invites.

Long exposure shots are most common against movement: think of cars streamlining down a highway, crowds of people in a mall disappearing into ghostly blurs, or the water from waterfalls blurring together into a milky smooth flow.

By capturing the entire time it takes to move from one end of your frame to another, your still camera is capturing a single frame of movement, but also capturing all the movement. So if you leave your shutter open for three seconds, and have someone walk across the frame for three seconds, the shot will capture all of that person's walk, but nothing will be in focus.

In other words, it uses motion blur to your artistic advantage.

Long exposure shots are typical at night, because the long exposure doubles as a way to brighten up a dark scenario. If you're shooting cityscapes, you can make bright city lights explode in a glorious array across skyscrapers and highways by lengthening your exposure time, and the secondary effect is that any movement will be blurred. Buildings don't move, so you'll have them in crisp focus, but any people and cars will turn into softly blurred images that create a sense of hectic movement.

If you're shooting a city during the day and want to capture that same hectic movement, you'll need to crank down the ISO and probably add a neutral density filter, which will darken your image and allow for longer exposures in brighter conditions.

An ND filter is also useful for waterfalls, which are rarely shot at night because of the lack of artificial lighting. So, because you'll almost always be shooting during the day, you'll need something to darken daylight to allow for your long exposure. This is how professional photographers capture those smooth flowing rivers and streams, too.

Light Painting

If you want to take long exposures to the next level, you can try out light painting—a very niche photography style that involves a lot of preparation, dedication and trial and error.

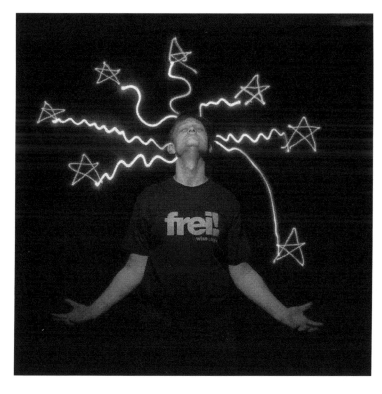

Light painting is literally painting with light. You'll need a flashlight, or some LED light source, and a totally dark scenario with your camera on a tripod. Set it on an extremely long exposure—something like 30 seconds or even a minute or two, depending on how much light you have available and how elaborate you want your painting to be.

Because there's no light except for your flashlight, you can use your flashlight as a paintbrush and create brushstrokes across the frame. When you review the shot, you'll see you've created shapes in much the same way as a painter created a work of art.

People use light painting in a number of ways: some illuminate objects in particular ways to create a rustic, old-fashioned look; others illuminate models standing still to create alien-like subjects; others spend minutes in front of the lens creating elaborate abstract combinations of circles and lines.

Light painting isn't for everyone—in fact, it's so niche that most light painting photographers specialize in that and don't bother with traditional landscape photography or portraits, because they prefer to explore this new variation on the medium. If you have patience and a flashlight, you might find it worth your while.

High-Dynamic Range (HDR)

High-dynamic range photography, shortened to HDR, is the latest trend in digital photography, overcoming problems of exposure balance when you're shooting something with a lot of darkness and light that needs balancing.

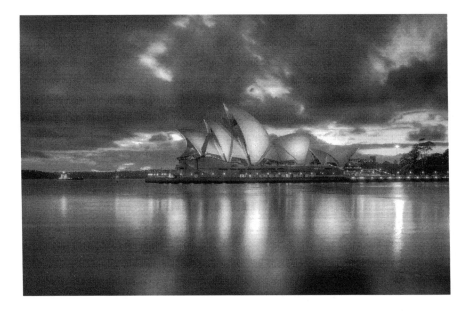

The concept is that you take three shots with different exposures. (You can use exposure bracketing for this, or grab three exposures manually depending on what you want to correctly expose with each.) You can then combine the three photos into one photo using a program like Photomatix. Between the three exposures, you should be able to correctly expose the entire shot—this creates a balanced image, rather than one that is awkwardly very dark and very light in different spots.

HDR photography is chic these days because it creates hyper-realistic images, making lights shine brilliantly against light-blue night skies and keeping everything in crisp focus. It often looks unnatural. Some people like this; others detest it, calling it hokey and overdone. But it often results in vibrant, striking images with powerful color palettes and truly innovative atmospheres.

The thing is, HDR photography didn't begin like this. It began as a solution to the common problem of needing multiple exposures in a single shot. Shooting a portrait of skiers on a snowy mountain, for instance, you'll be faced with the problem of the snow being extremely bright, the skiers' faces being darkened by shadows, and the mountains lit up by the sky being somewhat correctly exposed. By shooting it in HDR, it would allow for three exposures—one with the skiers' faces correctly exposed (but everything else super-bright), one with the snow properly exposed (but the faces and mountains in complete shadow) and one with the mountain background looking good (but everything in front of it looking a bit dim). By combining these three, you're allowing for them all to be in focus, well lit and looking sharp—and it won't look unnatural, either.

One problem with HDR photography is that, as you might have guessed from that example, it tends to lose depth of field. HDR-affected images might look shallow, and it's nearly impossible to do with a shallow depth of field, as in a traditional portrait scenario. But this is primarily a landscape technique, because otherwise, foreground lighting issues could be solved by adding external flashes and spot lighting on places that need brightening up—and in landscape or cityscape photography, you'll likely be shooting with a deep depth of field anyway, to make sure everything is in focus.

Regardless, HDR is a common technique that's worth playing around with. You'll need a tripod, and the composition of each shot must be completely identical for the shots to match up. Don't be afraid to overdo the hyper-realism at first and see if that look works for you. Maybe you'll agree with the purists, maybe you'll appreciate the bright colors and crazy lights. Either way, the important thing is that you expose yourself to it.

Fisheye Lens

This technique isn't difficult to pull off—it just requires a single lens purchase that will probably cost a few hundred dollars.

A fisheye lens is a super wide angle lens that doesn't try to balance the distortion that comes with a circular lens. What makes most ultra-wide angle lenses expensive is that they need to allow in a wide breadth of the frame without compromising the image at all. Fisheye lenses embrace that natural distortion, and photographers run with it.

Fisheye lenses are fun to play around with, especially if you're going for a surreal look. They can capture an entire room in a circular view, or interpret a beach as an orb-like landscape with a totally unrealistic but very distinct viewpoint, with the ends curving downward into the bottom of the frame.

There isn't much you can do with a fisheye lens beyond the single distorted element, but you can create fascinating close-up portraits while keeping the background in distorted focus, or simply look at landscapes in a whole new way. But be careful: fisheye lenses can make images look kind of tacky if overused, so try to find images that look truly cool and unique with them applied.

Forced Perspective

Perspective is a very fun thing to play around with. You know how things look bigger closer up, and smaller farther away? Play with that! You might recall vacation shots wherein tourists are doing things like "holding up" the Leaning Tower of Pisa, or holding their hand out in a pinching shape and "squishing" someone behind them.

Well, the same can apply for more artistic photos, too. Using perspective can create innovative portraits, but also play with nature in fun ways—you can make a flower look enormous in the foreground to balance out a mountain behind it, or frame a tree behind a transparent bottle, so it looks like the tree is captured inside. Always look for little details that can give you freedom to play around with reality.

Wide angle lenses are important here, because telephotos tend to compress images so their depth of field seems smaller. You should also use a higher f-stop to create as deep a depth of field as you can—otherwise, the background will be blurry, which will work against the effect you want. You can also use the Aperture Priority mode, which will lock in your aperture to make sure it doesn't change (if you're otherwise shooting on automatic).

Shaped bokeh

Shaped bokeh is a less common technique, more often done as a special effect for very specific purpose than by professional photographers.

Bokeh, as a reminder, is the word for the blurred-out hexagons or circles that appear automatically when you focus on a subject in the foreground. The mark of a good portrait lens is a soft, pleasing bokeh, rather than a harsh and pixelated one.

Well, there's a third option: shaped bokeh.

It's a bit of a DIY project, and you'll need a good portrait lens—something prime, or at least a lens that reaches large apertures of under f/1.8. Then, all you need to do is cut a filter for your lens out of construction paper with a particular shape in the middle and place it on the lens securely, using another piece of construction paper in the shape of a lens hood.

Set your aperture large and choose a subject to shoot—then fire away, and you'll notice that your background becomes cutely shaped like whatever image you cut out in your pseudo filter.

Go Further

There's no end to the tricks you can accomplish with your camera—we haven't even covered half of it. And if you engage in Photoshop and post-processing, you can learn a whole lot more.

The key to all these tricks isn't to teach you "the best" way to shoot photography, but to prove that you should never accept your own limitations. You can exceed them. Try something nobody's seen before. Combine these tricks, or experiment in different ways. No one's going to judge you just for trying something new—if nobody ever did, none of these styles would exist in the first place.

Chapter 6
What Type of Photographer Are You? (Yes, There's More Than One Kind)

No single photographer enjoys every form the art. When you're starting out, you might enjoy taking portraits, landscapes, trick shots and spots photos—but with time, you will probably find yourself falling more towards one style of photography than another. Or you might go through phases—so long as you decide to dive into a single style and really perfect it, rather than casting a wide net and staying there.

By now, I hope you've tried out a few of the tricks and photo styles we've discussed. That way, you can really appreciate what each one takes, and what kind of images you enjoy seeing and trying out.

In this quick chapter, I'm going to review the types of photography that might strike your fancy. Again, it's good to try them all—but try to specialize in a niche or two, and really appreciate and understand what it takes to excel in that, at least before you tackle another style altogether.

Portrait Photography

Portrait photographers need one thing most photographers never will: communication skills. Portrait photographers need to learn how to break the ice, talk to their subjects and get them to ease up and reveal their inner selves.

One of the greatest living portrait photographers, an artist who goes only by "Platon", has captured the humanity of dozens of celebrities and politicians, including actors like Christopher Walken and Will Smith, and politicians such as every United States president of the last several years.

Platon's technique is sophisticated—he acts quickly, and tried to approach each of his incredibly busy subjects with a quick icebreaker. I once watched a YouTube video of him describing a photo shoot of Russian president Vladimir Putin (a shot which later became an infamous icon via Tim Magazine), wherein he explained that he asked the Russian strongman what his favorite Beatles song was. Putin, whom Platon knew was a fan of the band, relaxed and replied: "Ahhh, 'Yesterday'." This gave Platon an in. He could break through the bodyguards and political business to reach someone on a human level. That's critical.

Landscape Photography

It's the job of a great landscape photographer to capture the emotional essence of a place and show it to others. Their goal is to inspire people to travel and better

appreciate the world in which we all live by showing everyone sites that they may never have known even existed.

That's the difference between a vacation photo and a landscape one: vacation snaps are mementos; landscape shots are invitations.

As a landscape photographer, you need to be aware of two basic concepts: what to look for, and how to shoot it. Not all great landscapes make great photo—oftentimes, valleys that might seem dazzlingly wide in person will make boring shots. You need to search for strong focal points and interesting details, and apply the classic rules of photographic art—natural frames, the rule of thirds—if you want to create beautiful works out of the world.

Consider mountain photography. At its best, mountain photography reminds us of how small we are. To capture a mountain is to capture its grandeur, its awesome magnitude against the minute details that surround it. We love looking at mountains, because they're so impossible: they're difficult to live on, difficult to summit and often difficult just to reach. If photography is the art of capturing what the eye cannot, mountains are the art's ideal subjects.

And yet, unfortunately for camera fanatics, the difficulty of mountains translates into photography, as well. Photographers have to not just hike the thing (difficult already), but also lug all that extra gear, and suffer the added pressure of being in the right place at the right time. They've got to be aware of lighting conditions, and be prepared to find a whole new angle of something that's existed for millennia. The best mountain photographers are avid hikers and patient artists, ready to trek up remote trails and bushwhack through the wild to capture something few humans have ever seen before.

Street Photography

Street photographers deal with candid shots—unplanned, spontaneous moments found on public streets. Street photos are best when they're unfiltered, raw and human.

Sometimes street photos are planned, but often they're not. You're meant to just head out with a camera and subtly take shots of people being themselves. This is a fundamentally dangerous art—especially in certain parts of the world, where photographing strangers is considered extremely rude, or at the very least might get you punched in the face and your camera stolen.

But for those who can pull it off, street photography is a classic form of photojournalism, or documentary photography, that captures a time and place better than any other form of the art.

Eugene Atget, a Parisian active around the turn of the 20th century, was arguably the first street photographer to gain public fame. His works show Paris the way it truly

was—vibrant, lively and full of color (even though his shots were black and white, of course). In America in the 1950s, this trend caught on with the hipster Beat movement, led by Robert Frank in an attempt to discover the real America by wandering its city streets, alongside contemporaries in different artistic fields such as Allen Ginsberg (in poetry) and Jack Kerouac (in literature).

Today, street photography is common, and arguably the cheapest form of photography. It's easy to snap a photo of people on the street—no flash, blur is fine—but it's much harder to transform this reality into artistic, productive forms of art.

Sport Photography

This very lucrative niche is great work if you can get it—but you need to invest heavily and have a lot of experience, first.

Athletes are great to photograph in action because they often strike terrific poses. Who doesn't love seeing LeBron James leaping through the air, his eyes wild and mouth screaming open as he reaches for the net above? Athletes are expressive, momentous and committed—ideal subjects for photography.

The problem is, they're also not paying attention to you. Needless to say, athletes move extremely quickly, and in order to capture a great moment, you'll absolutely need a good lens. Unlike landscape or travel photography, for which you can get away with an iPhone when absolutely necessary and still come away with a potentially decent shot, sports photos are strictly professionals.

If you're interested in trying it out, head to local high school and university games with a pack of gear. You'll need a strong camera and solid telephoto lens. Ask a coach or someone in charge if nobody minds that you're taking photos, because you love watching the sport and want to practice your shots. Often, the students will be so excited to see themselves afterward that they'll all look forward to the experience, and you might even be able to sell a few shots to the parents.

Cityscape Photography

Cityscape photography is, in many ways, a natural counterpart to landscape photography. The same general rules apply: consider skyscrapers as mountains, roads as rivers and glistening lamplights as a lower version of starlight.

The best cityscape photographers understand that cities are symbols. Cities symbolize the triumph of what men and women can create when they work together, an accumulation of electricity, steelwork and design. But good city photographers also understand that cities are kind of terrifying: they're absorptive monsters that consume us in traffic gridlocks. We see a photo of a downtown skyline, spot a small yellow square

of light coming from an apartment, and realize how small we are in these densely packed urban areas.

Good cityscape photography makes the viewer feel both things: awe and terror. It should make them feel exhilarated at the endless possibilities tucked into every corner of downtown Tokyo, but also petrified at the enormity of Shanghai's systemic twisting roads. From an aerial view we can spot all the boats in Toronto's harbor, the landmarks of New York's skyline, and the signature rivers coursing through London, Seoul and Paris.

When we see cities, we see everything.

The biggest difference is that cities change at night. A mountain is a mountain any time of day, but by night, a building transforms into a blaze of lights to challenge the stars, roads light up with moving dots of red and yellow, neon lights line the streets in attempts to catch your eye.

Visually, cities come alive at night.

When dealing with all this extra clutter, it's important to remember the fundamentals of photography, which still very much apply. You want to look for interesting angles, not just generic skyline shots. You need to know how to frame buildings of various sizes so the levels (or lack of them) play in your favor. You should understand how to see roads as leading lines and how to use exposure times to manipulate the movement of foot and car traffic.

There are a lot more factors to take into account, which can be difficult for first-time photographers. Don't see the human element as a burden, but as an opportunity to create exciting and dynamic images of the unnatural environment in which most humans live.

Travel Photography

Ah, travel photography! The broadest category of all! Travel photos encompass everything—cities, landscapes, portraits, street candids and even sometimes sports.

Good travel photography takes the viewer on a true journey. You're inviting them to tag along on your travel, be it to the deserts of Mali, the pristine beaches of Bali or a small mountain tribe in northern Laos. Every shot you take has to be reflective of where you are—a sense of place is important above all else.

With that in mind, even great shots that don't give a sense of place can't rightly be considered *travel* photos. A beach shot is nice, but unless you show me a local native or some cultural icon in the shot, I could be looking at a beach in Israel or California.

Cityscapes are fine, but cityscapes including ancient temples situated right downtown or magnificent global architectural icons actually make me realize what places look like.

You want to make your audience say, "I had no idea that's what Paris looked like."

As a travel photographer, you'll need to be diversely trained in every aspect of photography, because you never know what might pop up. When I travel, personally, I most enjoy taking street photos through food markets, because I feel they give the strongest sense of place and culture—we see people, food and architecture all at once. But you'll never want to come away from a city with only one type of shot. It's necessary to include a variety of shots, which is why diversity—in both skill and imagination—is key.

Wedding Photography

And now for something completely different: wedding photography isn't what you think it is, because what you think it is probably what *everyone* thinks it is.

A great wedding photographer treats weddings as art, not just moments to be accurately captured. A good wedding photographer can turn the most important day in someone's life into something beautiful they could never have imagined.

I'm talking about striking dramatic poses between the bride and groom (look up Moshe Zusman or Eigirdas Scinskas for ideas about what I mean), macros of placement details with beautiful bokeh behind them, and candid shots that don't just capture facial expressions, but combine those expressions with gorgeous framing and lighting in something more artistic than a simple memento.

Anyone can take photos at a wedding, and anyone with an SLR can charge money for it. But if you want to be a great wedding photographer, you need to have a game plan—a strategy for what you're shooting and when—and appreciate that your eye needs to be honed professionally even while people are ignoring you and going about their own lives. Sure, you can pop up and say, "Excuse me, do you mind striking a pose?" But candid shots are so much better with weddings—and for that, you need to be a professional, high-quality fly on the wall.

Wedding photographers need to be constantly alert and move swiftly, because these events are full-blown parties that you'll have trouble stopping just for a perfect shot. You need to do a tremendous amount of pre-planning and be prepared for several nonstop hours of capturing as many moments as you can in an artistic way.

For engagement photos and wedding portraits, you need all the same people skills as portrait photographers, but with the added stress of this being a generally high-anxiety environment where your subjects may have no idea what they're doing, and are too

distracted by the thought of lifelong commitment to commit five seconds to a genuine pose.

Wedding photographers need to be in control. Set the tone, and your subjects will relax and follow suit.

Photojournalism

If your background overlaps at all with journalism, or you have a craving to know all about current events, or you love rushing into danger when others are running away from it—you might find luck as one of the fewer and fewer working photojournalists in the world.

Photojournalism will always be in demand, because people need to see what's going on in the world. But it's an extremely demanding form of photography—possibly the most demanding, because it requires a quick mind, brave attitude and still all the knowledge of what makes an image sing.

Photojournalists have to understand a wide array of photography. They're closest in kin to spontaneous street shooters, but will also spend a good deal of time posing subjects like politicians and artists. Transit is also a necessary evil of photojournalism that most aspiring enthusiasts don't consider—how do you get from one side of the city to the other in half an hour? Owning a car is critical, but being able to bike or hop in a taxi on a whim is also often a key component.

The fact is, photojournalists for newspapers are catch-alls, who need to excel at having both communication, technical and artistic skills. You need to be able to think creatively and grab a shot for a story even when there's no obvious shot, or show up to a neighborhood looking for an image, and be able to turn whatever's there into something worthy of print. There's little time for Photoshop, and you'll have editors breathing down your neck every step of the way.

But for the adrenaline junkies out there, there's no better job.

Nature Photography

Love animals? Have patience? Nature photography could be your calling—the refuge of every quiet animal enthusiast on the planet.

There tend to be more amateur photographers in the nature field than in most other areas of photography, because nature photography hobbyists tend to be passionate about the cause. They love sitting in one spot waiting for a wild mammal, bird or insect to appear for the briefest of moments. And when you capture that image, the results can be totally unique and mesmerizing.

Nature photography is more than wildlife photography, of course. Hiking out to hunt for rare flowers or bird watching are both relatively quiet, meditative outlets for photographic sense.

Nature photographers will likely leave the ultra-wide lenses at home. Extreme telephotos are the lens of choice, those enormous camouflage super-zooms that require extra luggage and cost thousands but take quiet, faraway shots like nothing else.

To turn nature into art takes more skill than patience, though both are key components of this highly specialized form of photography. It's also difficult to make it lucrative—aside from the few lucky buggers who sell to National Geographic, this will likely remain a side hobby for enthusiasts alone.

Fashion Photography

On the other side of the spectrum, fashion photography—arguably the more lucrative sibling of portrait photography—is a guaranteed way to stay in business. Fashion photography is up there as one of the most common types of professional photography, simply because of the size of the media game—clothes retailers, cosmetics companies and, well, pretty much anyone selling anything these days relies on fashion photographers to make their product look sexy.

Fashion photography is different from portrait photography because of the heightened emphasis on style. Every type of photographer needs creativity as a cornerstone of their art, but fashion photographers are more reliant on their ability to blend human imagery with abstract art—to contort bodies into shapes, and use makeup and inventive clothes to create unnatural images that bend our minds in innovative ways.

Of course, traditional fashion photography exists also—but it is simultaneously a realm of great experimentation, and is ideal for creative minds to find each other and work together.

Best of all, it's relatively easy to create your own portfolio. I know several budding photographers who've gotten great exposure and taken excellent shots of amateur models simply by striking up a pro bono deal—both the models and the photographers need shots to fill their portfolios, so why not work together?

Commercial Photography

For everything else in the world that needs photographing, there are commercial photographers—arguably the most ubiquitous, successful and standard form of working photos out there.

Commercial photographers shoot anything that needs shooting—products, mostly, like cars, clothes, furniture or groceries. If there's a photo of something in a newsletter, magazine or newspaper, a commercial photographer took it.

The upside to commercial photography is that it pays the bills, but most commercial shooters tend to have side hobbies as well—something less lucrative, like nature or landscape photography. Commercial photography is not a great outlet for creative juices.

Much of commercial photography relies on understanding artificial lighting and having a strong sense of comfort around a photo studio. Setting up accent lights and back flashes is critical to creating the most appealing situation to see your subject.

And the last bit of good news? Once you break into the industry, it's easy to keep making contacts and getting jobs.

Specific Trick Photography

As outlined in the previous chapter, there's no shortage of trick photo styles—light painting and forced perspective come to mind as particular specialties that hobbyists engage in.

If you want to engage in trick photography professionally, the market definitely exists. You'll likely be spending a lot of time in Photoshop (this is true of every photographer, but it's especially true of light painters and HDR lovers), but you might find yourself feeling constrained by reality.

Trick photographers see our physical world as just the first stepping stone in a much larger game.

Anything I've Missed? Go For It

There are more types of photographers, of course. There are sub-specialists for every genre I've just mentioned. (Kids' portraits, concert shots, food specialists, pet photos—if someone needs a photo, someone needs a professional.) If you can find a niche and you love to shoot it, market yourself hard—soon, word will spread, and you'll find yourself keeping busy.

Like I mentioned above, few photographers stick to one single style. Likely every photographer will dabble in commercial work to pay the bills, enjoy landscape shots while on vacation and try to win some National Geographic contests with candids or nature shots. Rarely does one style occupy a photographer's entire life.

But do yourself a favor and try your hand at everything. Throw a few darts at the board and see what sticks. Explore your possibilities, and you may find that you develop an interest in a subject you never realized you cared about before.

Chapter 7
Crash Course to Promotion (From Instagram to Blogging & More)

Photography has changed a lot in 20 years. It used to be true that anyone who took a photograph would reel the film back after finishing all 24 shots (sometimes 25, if you were lucky!), bring those shots into a store, choose a paper quality (matte or glossy? Borders or no borders?), wait a few days for them to print (or pay more for hour-service), pick them up, take them home and store them in an album, tucked away in some living room cabinet until you moved out.

Things have sped up since then. Obviously, now anything that takes a photo—phones, cameras, even video recorders—can be hooked up to a computer and you can share your photos across the web instantly, with friends and family, no matter where they are.

Back then, prints meant something. Now they mean less—unless you're especially proud of your work. As an amateur or professional photographer, you might be inclined to show off your shots to the world. No longer do you have to physically just print them out, of course—you can upload it to Facebook, tweet it or even Instagram a smartphone shot that you felt really popped.

But why not go one step further? If you really want to show off your stuff, you might want to consider a photo blog. Blogging sites like Wordpress and Tumblr offer dozens of free templates specifically designed for photographers to exhibit their works. Many are sleekly designed and optimized for high-resolution images.

What that means is that, unlike Facebook, which will compress your images into blurry messes with rough edges, these websites are created specifically to handle the full depth and breadth of your shots, allowing you to take large and detailed photos that the internet can actually appreciate.

There are loads of outlets, too, that are similar to blogs but operate more in a gallery style. Two major players in the online photography world are Flickr and 500px. Both are essentially portfolio websites where words are pushed to the sidelines and images are emphasizes in a very cool, very contemporary design. Pinterest is another great photo-centric social media platform that will easily allow people (mostly women, by demographical definition) to share your shots by "pinning" them on their own boards. Networking is the best form of what's called "earned media"—advertising without paying for it, but rather by exposing yourself directly to your potential audience.

Note that you should only start a blog if you plan to keep it going with regular updates, and if you have some sort of theme to convey—"Street Style in Seattle", say, or "Candid Images From My Window." Daily updates aren't necessary, unless you want to get super-serious and start to monetize your blog; otherwise, weekly or bi-weekly updates are fine, as long as you keep it consistent.

How to Set Yourself Up Online

First, if you're opting to start a blog, you'll need to choose a name for your blog. Some photographers simply use their own names, while others choose something lyrical or metaphorical.

Once you've got your name set, you'll want to choose which photos you're going to display. For sites like Flickr and 500px, which are generally understood to be static web pages made for photographers' full portfolios, you can just upload a whole batch of shots and never touch it again. It's like a rough cut of a film. You can at least divide your photos into sets—"Summer 1999" can be one, or "My Hawaiian Vacation." If you want to really trim your selection down to just the best, keep only around a dozen photos in each set, and don't overload any visitors you may have with too much stuff. Too much content can be overwhelming.

The other nice aspect of Flickr and 500px is that they automatically read and expose (pending your approval) the image's metadata, including what camera, lens, ISO, shutter speed and f-stop you used. That creates a strong community feeling, so others can clearly see how you took a shot they might love.

A tip for drawing visitors: use the file names of your photos to your advantage. Metadata in websites is important for improving how strongly your site performs in a search engine beyond simple facts. Instead of using the default file name that your camera assigns ("IMG_9983" or whatever), rename it to what it is that might draw in Google searchers: "Mt. Fuji spring" or "Southeast Asian food."

If you're blogging, and you've chosen a name and a theme, you're more or less good to go. Modern blogging websites are easy enough to understand that anyone can set one up. A brief "About Me" page is standard—mention what camera you use (in case people are curious; it's a nice detail for hobbyists) and what the subject of your blog is, and maybe some interesting facts about yourself.

Then, voila! You're basically done. Just keep updating your site regularly if you need to, and you'll notice that visitors will find it on their own.

Boost Your Blogging Self

Blogging is a great way not only to advertise yourself, but also for a host of other reasons.

First is that, if you're good and lucky enough, someone might notice you and offer you a photography job, or want to **sponsor your photography**. A number of professional photographers are noticed by camera companies that produce tripods, bags or

accessories (Lowepro and Really Right Stuff are good examples), because they want to see influential photographers sporting their goods on excursions or in popular videos.

If that doesn't happen for you, bigger website hits still aren't bad: if your hit count rises high enough, you can offer competitive rates for advertising. Even if you're not taking your photography to a professional level, who doesn't like a bit of extra cash?

The other great thing about photo blogging is that you're **pushing yourself to shoot.** It's all too easy to find yourself falling into the same old trap, saying, "I love photography, but I just don't get out and do it enough." But if you have a few Flickr friends or blog followers, you'll have some outside pressure to work harder at it. Even those of us who love taking photos need a bit of a nudge in the right direction sometimes.

Lastly, if nothing else comes of it, **it's something of which you can, and should, be proud**. Personal projects are well documented ways to boost individual happiness and a personal sense of purpose. Thousands of people do triathlons and never bother to place first, second or third; others jam in garage bands that never play publicly, or even perform a concert. That's what makes it a hobby. It doesn't have to be for public exposure. The pride of doing what you enjoy should be reward enough.

So take a second look at your photos. Have you ever surprised yourself? Think any are actually pretty good? Show the world. If people respond, great. If not, don't sweat it— it's still a document of your success, even if it doesn't rise above the thousands of other personal photo blogs out there. After all, you're not trying to impress anyone but yourself.

Conclusion
It's Time to Get Out There And Take Some Shots!

I'd like to send you off on a personal anecdote.

When I was just starting out in photography, I didn't know the difference between f-stops and aperture. I couldn't wrap my head around which was big, which was small, and how it affected exposure—or was it depth of field?—and I thought, for the life of me, I'd never be able to grasp the basics of a technology that long predated the digital revolution.

Then something happened. I was explaining it to someone else, someone even newer to photography than I was. We were out on a travel shoot in the mountains and I showed her, plainly, what the difference between the two was, by taking two shots with starkly different apertures and comparing them immediately on the screen.

Suddenly, I realized something. I realized that I'd actually understood this much better than I gave myself credit for. I actually understood this so well I could describe it, which I'd never done before—I could actually visualize the difference and explain it, which helped me formulate my own thoughts into reality. Staring at the difference between those two shots, I realized that I was only holding myself back from believing that I could truly understand this, that I didn't comprehend that I could understand photography—that, in truth, the whole thing was much simpler than I'd ever appreciated.

The fact is, we hold ourselves back all the time. Sometimes this caution is a good thing—it prevents us from leaping headfirst into dangerous scenarios, being foolhardy and getting into trouble. But sometimes this caution is misplaced, or stressed upon long after we can afford to ditch it. Sometimes we rely on the crutches even after we're able to walk, and all because we're afraid to speed up and take a few steps on our own.

I am exposing myself and my former insecurities in this way to prove that if I can do it, anyone can. I, like so many others, was not born a photographer, but rather grew into the hobby out of pure personal interest and little else. Odds are, if you're reading this book, you also feel like you weren't born a photographer. That's okay—few are. Certainly none of us was born with a camera in our hands.

The fact is that becoming a photographer of any grade, professional or amateur, requires patience and training like any other art. Don't feel dissuaded, even when you're down. So much of photography especially boils down to dumb luck—just being in the right place at the right time—that even amateurs can take great shots, and even professionals can be stumped by uncooperative weather or bad timing. Photography is a gambled art.

So don't get down on yourself—get shooting instead. Never let a few failures get you down. Take multiple shots of everything. Start bringing your camera out on long walks. Save up for more lenses, flashes and tripods. Invest in your hobby, and you'll experience the fun of playing with these new toys, and appreciate the effort it took to grab certain shots.

Be bold and experiment. Try new tricks. Find your shooting style. Even if the shots don't work, you'll at least know what your camera can do—and be amazed by the process.

Introduction
A Picture's Worth a Thousand Words

Do you have a favorite photograph right now? If you don't, find one online. Browse through the World Press Photo archives, scan Flickr, flip through a magazine. Find a photograph that speaks to you—that makes you want to hang it up on your wall and look at it every day.

Got one? Good. Now tell me: why does it work? What makes the photo sing? What makes it come to life and speak to you?

This image below is one of my favorite shots that I've taken. It's of a morning ritual in Luang Prabang, Laos, where monks distribute alms to the poor every morning at 6 a.m.

I like this photograph not because it's an objectively great one, but because it tells a story: there's a boy, clearly poor, clearly being taught humility, thanking the grace of a monk who is giving him a gift.

But on a compositional level, there's something attractive about it—the starkness of the monks' orange robes against the drab gray background, the positioning of the boy in the frame, the disappearing line of monks. We'll get into this more in the book—what makes a composition work.

We rarely have the opportunity to walk into an art gallery or photo exhibit, but when we do, we too often say, "I like this—but I don't know why." That's fine. Not everyone studied art history in school. Great art, arguably, speaks to us on an emotional level, not an intellectual one; some say that to analyze and deconstruct an image is to devalue its artfulness and turn it into something harshly academic.

In other words, we should be able to just look at a piece of artwork and *feel something*, maybe good or bad, maybe overwhelmed or intrigued, but at least we're *feeling something* that forces us to connect with our emotions. That's why it's worth a thousand words: you could write a thousand-word essay describing it, the tonal colors, the evocative

Photography is a funny sort of art because it deals with the constraints of the real world. Good photography speaks to people who "don't get art" because it is still real—a photograph of a water droplet splashing into a cup may look abstract and computer animated, but the knowledge that this is a real thing, something we do every day—that is, drinking water from a cup—keeps us from dismissing it as some abstract nonsense. Instead, like all good photography, it forces us to reconsider the world in which we live.

That's the essence of great photography, so I'll repeat it again: *It forces us to reconsider the world in which we live.*

There are a myriad styles of photographic art: you can shoot an abstract pattern, like ceiling tiles; you can nab a close-up that exposes every hair on a lion's mane; you can take a glistening portrait of your daughter in her new yellow dress against a vibrant green field; you can hold your camera at your hip and snap candid street shots of strangers shopping for apples; you can use an extreme wide-angle lens from the top storey of a condo to capture the zooming lights and futuristic landscape of a metropolis.

What you shoot is up to you. This book will help you understand what makes certain photos great, what makes others lousy, and which style will work best for you.

The important thing is that I help you move past flipping your camera onto "Automatic" and discover how to take proper shots that enrapture the heart. These are fundamental rules that apply to every artist, really, but especially photographers.

The fact is, anyone can be a photographer. Anyone can pick up a camera and take a brilliant shot. You see things every day in your bedroom a certain way; this book will help you see them a different way. And, in fact, most professional photographers never studied photography—they taught themselves as they pursued their passion. Photography school is nice for social connections, but the technical aspects can be self-taught just as easily.

That said, practice is imperative. Once you read this book, you can't just put it down and call yourself a photographer. You'll need to go out often—every day, even—and take

some shots around your neighbourhood. Look for new inspirations and ideas. Nobody got good overnight.

Once you learn the basics, you can take stunning shots of almost anything. So, in addition to a basic understanding of composition and lighting, you'll be able to pair it with an eye for what's interesting. That's all there is to it—insight into what makes photographs great technically, matched with an understanding of what makes photographs great emotionally.

In other words, I'm here to help hone your eye.

I can't take the photos for you, but I can show you how to get the most out of any camera you have, even if you've never touched one before.

Photographs are beautiful mementos of vacations and reminders of loved ones, but they can also be objectively fantastic art. So if you want to upgrade your photographic skills from travel memories to impressive works of art, I suggest you keep reading, keep your camera close, and keep shooting.

Chapter 1
The Most Important Question of All - What Makes a Photo GREAT?

Isn't this always the main question? Professional photographers try to answer this one all the time.

The simple answer is that you should care about what you're shooting. If you're emotionally struck by an image, you might see it in a certain light, a particular way—try to capture the essence of what makes that moment special for you with your camera. If you look at your shot and you aren't satisfied, consider what's wrong with it. We're going to quickly explain a few ways you can do that in this book, by examining the technicalities of a photograph—lighting, composition, exposure, eye paths, all that fun stuff—but not quite yet.

First we need to understand *why* we are attracted to photos. Or, rather, *what* attracts us to looking at pictures of things. It taps into a voyeuristic urge we all have to watch—the same thing that makes it such fun to watch TVs and movies.

Basically, people love eavesdropping.

Tell a Story

One thing that makes a photograph great is its ability to tell a story or describe a moment in time. In photojournalism or travel photography, we see portraits of humans

living their lives and feel like we know them based on this one photography. My earlier photo of the Lao monks is a good example of that.

Before we go too much deeper into this concept, I want you to look at some popular and beautiful photography blogs.

Humans of New York (http://www.humansofnewyork.com) is a great example of human storytelling through photography. The photographer behind the project, Brandon, is an inspirational photographer who shoots and conducts short interviews with totally everyday people in New York City. We learn intimate details about complete strangers, and through Brandon's eye, we catch a glimpse of their lives.

Another excellent site to check out is Exposed Planet (http://exposedplanet.com), where photographer Harry Kikstra aims to "share the beauty of our planet" by exposing people to little-seen realities like a mostly shirtless Surinam family in French Guiana or the stark contrast of a sunrise against the mighty darkness of Vallenaraju, Peru. Kikstra has some touching views of the world himself:

"Nowadays negative press & media might make people scared of everything foreign or different: culture, religion, people and the places themselves. This xenophobia is taking over our lives and prevents us from seeing the real world as it is: a wonderful place with beautiful people. There are no bad or evil countries, religions or people. There is bad and good people in every culture, including your own."

These blogs work because they tell stories that evoke emotions. Like I mentioned in the Introduction to this book, they make us reconsider our view of our world.

On a deeper level—the "why we look at photos in the first place" level—it's arguable that humans have an *innate desire to connect*, to feel less isolated and be drawn together as a society. We are social creatures. The reason we enjoy looking at photographs—especially photographs with people in them—is the same reason we enjoy watching theatre plays, movies and TV shows. We enjoy storytelling. All these art forms—paintings, too, and poems, in a more abstract way—are all ways for humans to tell stories to one another.

When 12-year-old Afghan Sharbat Gula was photographed by Steve McCurry for *National Geographic* in December, 1984, neither had any idea the power that the photograph would carry. The cover-page image—which later became one of the century's most recognizable photographs—was known simply as "Afghan Girl", sometimes referred to as "the Afghan Mona Lisa", and if you Google search the image you can see why. Gula's piercing gray-green eyes show deathly seriousness about her impoverished situation while her country was under Soviet occupation.

Sure, the composition and lighting make "Afghan Girl" a good photo *technically*, but what makes the image sing is the sincerity that no one can teach. McCurry had seen

something inspiring and captured the essence of it. The result is a story that we all understand without words needing to be said.

So as we go through these next few chapters, remember that what we're looking for, constantly, is honesty and evocation. Don't worry about the technical aspects just yet—we'll hit that soon enough, and by the time we approach it, hopefully it won't feel so intimidating.

<u>To check out the rest of "Photography NOW! - The Ultimate Guide to Take STUNNING Photos and Change the Way You See the World" go to Amazon</u>!

Ps: You'll find many more books like these under my name, William Wyatt. Don't miss them! <u>Here's a short list</u>:

- Emotional Intelligence
- Communication Skills
- Persuasion Power
- 7 Reason Why You SUCK at Sales (And What to do About It)

- Introverts Will Rule the World
- Self Discipline NOW

- Charisma NOW
- Much, much more!

About the Author

 William Wyatt is a serial entrepreneur, having founded several companies throughout his life. He focuses his energies on the achievement of individual success, as he believes every man and women on earth were born to be successful.

He has leaded numerous teams within his business career, maximizing each and every time the effects of proper management. During the past two decades he has acquired a powerful set of leadership tools, which in turn allowed him to take his communication & social skills to the next level.

Being a big believer of the importance of self development in every area of life, he's constantly expanding his knowledge and testing out new things. He enjoys sharing experiences with other business leaders as well, as he's certain that surrounding yourself with the right people can indeed skyrocket your life.

Born in 1964, William has a curious mind. He is student of history, always willing to research the lives of great individuals. He defines himself as a "student of infinite mentors", finding in all of them valuable knowledge to be incorporated.

William enjoys publishing books that can make a real impact in people's lives. If you have any suggestions or would like to have a certain subject covered in a future book, please send an email to williamwyattbooks@gmail.com and we will get back to you.

Thanks for reading!

William Wyatt